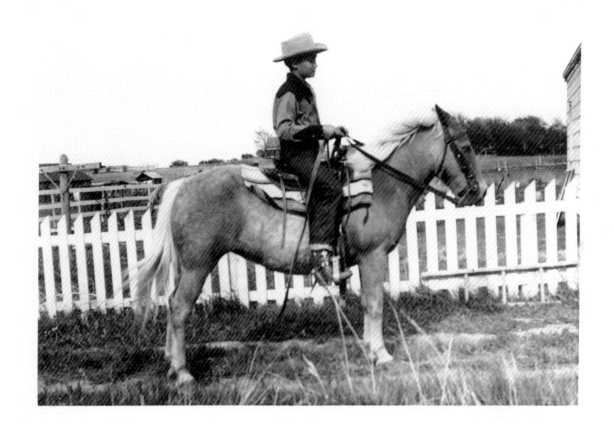

COLORADO'S VALENTINE

FORWARD AND ACKNOWLEDGEMENTS

The University Art Museum at Colorado State University could not be more pleased then to present the work of the Fort Collins born artist De Wain Valentine within the very walls where De Wain attended high school. The University Art Museum is located in the multi-disciplinary University Center for the Arts, the renovated historic building that opened as Fort Collins High School in 1924. Both De Wain Valentine and his mother, Rouine, graduated from the high school, and it is most fitting that this exhibition brings De Wain's work to a Colorado audience and that this publication explores the Colorado roots of his extraordinary career.

This project is due to the generous participation of a number of individuals. First and foremost I wish to thank De Wain Valentine for his enthusiastic response to this project and for his kindness. The historical essay in this catalogue results, in great part, from a number of interviews with the artist and I am most grateful for his patience with my repeated questions and clarifications. De Wain and Kiana Valentine hosted me and my husband in their Los Angeles home and we are thankful for their kind hospitality, warmth, and good humor. I am also most grateful to Kiana for the beautiful photographs of De Wain's work and her tireless administrative support with details.

Many friends shared their memories of De Wain. I am especially grateful to Sid and Jayne Schetina and to Reg and Mary Ann Hayworth for their critical assistance. Thanks are also due to Ted Davis, Jerry Johnson, Roseanne Knight, Peggy and Bob Mangold, Marian Pike, Garth Rogers, Ralph Schneider, and Dave Yust for sharing memories of Fort Collins High School and De Wain's Colorado years. The staff at Fort Collins High School, especially Ellen Danforth, Emily Steele and Allison Alter, enthusiastically supported this project recognizing a stellar alumnus. I am also extremely grateful to essay contributor Peter Plagens. Peter was the first visitor in Colorado State's Critic and Artist Residency Series, and has remained a great friend of our institution.

This exhibition is made possible with the support of the FUNd at CSU's Critic and Artist Residency Program endowment, the City of Fort Collins Fort Fund, the Lilla B. Morgan Memorial Fund, and BEET Street/AIR (Art Incubator of the Rockies). Without the generous support of these sponsors this exhibition and publication would not have come to fruition.

The museum staff works tirelessly and quietly on all of our exhibitions. Special thanks are due to our adjunct curator, Dr. Eleanor Moseman, for reviewing the historical essay and for her insightful suggestions. Deborah Craven not only designed this publication but assisted with research. Thanks are also due to Keith Jentzsch, preparator extraordinaire, and to Suzanne Hale, our very dedicated registrar. Heather Hull assisted with research and Jennifer Clary assisted with public relations. Finally, I must thank my husband Dr. Elmo Frickman, deputized as an assistant on this project, for being there throughout the journey.

Linny Frickman
Director

DE WAIN VALENTINE AND THE PROFUNDITY OF PLEASURE

1. you can take the boy out of colorado...

At dinner, recently, in a neighborhood restaurant in New York—which he's visiting to tend to some business relating to the art world's rekindled interest in his work—De Wain Valentine refers to himself as "the old cowboy." He says it with a mildly rueful smile, partly because he's now 75 and, although he's lived a pretty good life near surfable beaches in California and Hawaii, and has seen his work enjoy both commercial and critical success, he has never quite hit the pages of the history books with the impact of some of his contemporaries. He also says it because he is kind of an old cowboy. Valentine was raised around horses in Colorado, and got his first Stetson when he was three years old. He remembers the hat as being as tall and wide as he was.[1] Today, a cowboy hat—he fancies gunfighter black—is still as much a part of Valentine's head as his curly, dirty blonde hair.

"Cowboy" has other meanings, too, that can apply to Valentine. In the art world, it's someone who forgoes the security of, say, an art-teaching job in order to stay full-time in the studio, and takes his chances with galleries and collectors rather than dance to the tune of an academic bureaucracy. That—except for a few guest gigs early on—is Valentine. In southern California art precincts, the term also implies somebody who's somewhat off the Brentwood lawn-party trail, who doesn't have his studio nestled in one of those "creative community" neighborhoods. Valentine does his work down in what the architecture critic Reyner Banham called Los Angeles's "Plains of Id," in Gardena, of longtime draw-poker-palace fame. His neighbor makes dental ceramics.

Before he hit puberty, Valentine was finishing car bodies with multiple layers of lacquer, and when his car-dealer dad started selling boats, he became familiar with fiberglass. Yes, Valentine painted and studied with the likes of Richard Diebenkorn and Clyfford Still at the University of Colorado in Boulder. But "plastics"—a catch-all term

for synthetic sculpture materials such as Lucite and cast resin—is where Valentine started, maintained, and barring any sudden, late-career 90-degree turns in his aesthetic, ended up. During a stop in Chicago on a postgraduate trip to New York, trying unsuccessfully to interest galleries in his sculpture made with plastics, Valentine visited the Art Institute, where he encountered work by Larry Bell who, he's said, was already one of his heroes. Inspired, Valentine moved to Los Angeles in 1965 and taught a class in "plastics technology" at U.C.L.A.

2. "are you listening?" "yes i am." "plastics."

Valentine's first major work—one that's one of the foci of the Museum of Modern Art's recent reinstallation of its mammoth permanent collection—*Triple Disk Red Metal Flake - Black Edge* (1966)—is, however, not the kind of "plastic" work we've come to associate most with Valentine. It's essentially a *reductio ad aestheticum* of a beautifully customized hot rod—three tilting, bulging discs leaning diagonally like the racing car wheels in the great 1913 Jacques-Henri Lartigue photograph, *Car Trip, Papa at 80 Kilometers an Hour*. *Triple Disk Red* is a "fantastic object" (an oft-employed term for a certain kind of 1960s and '70s L.A. art), as space-agey seductive as anything produced during the same year by Craig Kauffman (in vacuum-formed Plexiglas), Larry Bell (in chromed steel and electro-plated glass), and even Robert Irwin (in synthetic polymer on aluminum). It's heavy on applying custom-car and surfboard vibes to an *objet-d'art*, but as yet still light on being the perceptual and ontological mysteries that Valentine's cast resin discs would later be.

There were other, and formidable, resin-casters in the L.A. art world of the time, but works such as Peter Alexander's *Cloud Box* (1966) were still pedestal-small. Valentine wanted to go big, to go beyond the conventional wisdom that 50 pounds of polyester resin was about as much as one could cast without the piece

cracking, bubbling, or becoming foggy. With the collaboration of chemical engineer Ed Revay, Valentine came up with his own material, "Valentine MasKast Resin," that enabled him to cast the large, freestanding, transparent colored discs for which he became most well-known. The discs weigh a couple of tons but, as Valentine told me a long time ago, he could cast one "without even a bubble the size of what you'd find in a bottle of 7-Up."

The problem—if it can be called a problem; it's more like a coming up barely short in the lifetime achievement awards—was that Valentine's objects fell into a kind of art-critical crack between L.A. art's smooth, shiny, sunset-colored objects that married the technological aesthetic of southern California's aerospace and movie industries to intimations of a great Zen one-ness, and the "light and space" art of Irwin, Jim Turrell and others that explicitly embodied (or disembodied) that immaterial one-ness. Over time, a gauze of technological curiosity—more, "Wow! How did he do that?" than "This causes me to wonder about the meaning of life"—began, unjustly, to attach itself to Valentine's art.

3. phenomenology to the rescue

The solution—that is, giving credit where due to the profundity of Valentine's work—is not so much learning, intellectually, how to look at one of his cast resin sculptures, but in allowing oneself to regard the object less as a thing, and more as an *experience*. The fancy name of this practice, this letting go, this *allowing*, is phenomenology. Although the philosophical discipline of phenomenology dates back to Edmund Husserl and the turn of the previous century (or even G.W.F. Hegel at the turn of the century before *that*), the key work—albeit densely written—is Maurice Merlau-Ponty's 1945 book, *The Phenomenology of Perception*. A relevant quote: "In perception we do not think the object and we do not think ourselves thinking it, we are given over to the object and we merge into this body which is better informed than we are about the world."[2]

Look at a Valentine disc. (The large discs are the best stimuli, but his other cast resin works are also instructive— and beautiful.) Its undeniable weight, mass and presence notwithstanding, the sculpture is simultaneously a kind of installation—not the "installation art" sort, but an activator of the space around it. Rather than being put at a psychological distance from the art object (a main point of orthodox, opaque Minimalist sculpture), one is drawn toward it. With a large disc such as *Circle Blue*, 1970, with the approximate wingspan of an average human, this feeling is enhanced by the object's seeming to be a kind of other person. The transparency of the piece manages to pull one perceptually *through* the work, through a kind of

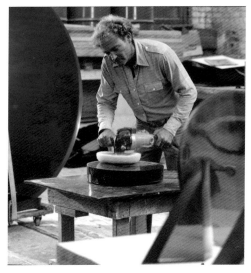

De Wain Valentine, *Circle Blue*, 1970 in Venice, CA studio, 1970

worm-hole of spatial distortion, to the other side and a charged awareness of the space *around* the sculpture. Valentine's talent, his craftsmanship, and prescient sense of what a piece of three-dimensional art could do if certain preconceptions—in force in modern art when Valentine began his sculptural sojourn in plastics—were cast (pun intended) to the side, make the experience an aesthetic one, a pleasurable one. In other words, art.

— Peter Plagens, New York

ENDNOTES

1 Bondo Wyszpolski, "Valentine's Day," *Easy Reader*, December 11, 2011, http://www.easyreadernews.com/42071/pacific-standard-time-valentine/

2 Maurice Merlau-Ponty, *The Phenomenology of Perception* (London: Routledge, translation by Colin Smith, 1996), p. 238.

COLORADO'S VALENTINE: A JOURNEY FROM FORT COLLINS TO VENICE BEACH

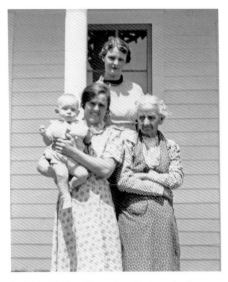

De Wain Valentine, Granny Lass, Great-grandmother Nelson, Rouine Valentine, Fort Collins, CO, 1937

In virtually every interview that De Wain Valentine has given, and in most of the critical literature on his *oeuvre*, his Colorado roots are mentioned as important to his artistic practice. Valentine, the only child of Glenn and Rouine Valentine, was born on August 27, 1936 in Fort Collins, then a small town with a population of approximately 12,000 located along Northern Colorado's Front Range. Despite an extremely prolific and lauded career, Valentine's work is virtually unknown in his hometown and has not been exhibited in his home state of Colorado since 1971 when he was included in Lewis Story's *73rd Western Annual* at the Denver Art Museum.[1] However, Valentine's Colorado connections are crucial to understanding the evolution of his sculptural innovations.

Valentine's work is situated and understood in light of his experiences in Los Angeles in the 1960s and 1970s as part of a larger movement popularly known as Light and Space, and for his lifelong interest in working with synthetic materials. His work deserves examination, however, through a wider lens that takes the artist's early years into account, especially in terms of the influences that shaped, and continue to shape his practice. These experiences include a love of rocks and lapidary techniques, an early fascination with the aesthetic possibilities of acrylics and resins, enthrallment with polished surfaces that reflect and refract light, as well as a love of car culture, all of which were present in his Colorado life. The traditional narrative argues that the Los Angeles scene of the 1960s and 1970s emerged, in part, because of an accelerated Southern California

car culture, surfboard culture and the aeronautics industry. These influences were pivotal to the artists who exploited plastics during this period. But for Valentine, the influences were already ingrained in his Colorado upbringing, not new, but ripe for exploitation and exploration. Valentine left Colorado for California in 1965, not only to seek an atmosphere with like-minded artists where he could continue his artistic growth, but because he had *already* established a level of expertise that allowed him to teach a course in plastic technologies at U.C.L.A. In the literature on Valentine, his Colorado roots are often mentioned, but one writer has argued for a more prominent reading. Peter Frank asserts, "he had developed his techniques not in California but in his native Colorado, and … came to L.A. nearly fully formed as a finish/fetish minimalist…"[2]

Imbedded in Valentine's practice is a deep sensitivity to a complex geography – both the physical geography of landscape and a cultural geography that *together* encompass the natural characteristics of a place and its locality in time. Valentine has noted "In Colorado where I was living and painting and making sculpture I had a love affair with the clouds and the mountains. You didn't see the air in Colorado. It was just crystal. When I moved to California the smog became a substance. And the quality of the light had a body to it that was just thrilling." [3] Valentine's work bloomed in this light on the beaches of Venice where he immersed himself in a new complex geography of surf and surfboards, but it germinated in his native Colorado where a young Valentine embraced both the geologic and the technologic as early as the late 1940s.

Valentine's father, Glenn, hailed from a family of Texas sharecroppers. He moved to Colorado as a young man after falling in love with the state. Valentine's mother's family had settled in Colorado in search of gold,[4] first discovered west of Denver in 1850. His mother, Rouine Schmidt, was born in the small mining town of

Silver Plume, a settlement known for its importance in the Silver Rush of the 1870s. Valentine's fascination with minerals and gemstones, in a sense, was in his genes, as it is in the history of the state and the Fort Collins area itself. During the Gold Rush of the 1850s the area around Fort Collins became a pathway travelled by gold seekers; the route cited in emigrant guidebooks eventually led to the establishment of the city.[5] And the state of Colorado is known for its rich mineral deposits including gold, silver, aquamarine, topaz, rhodochrosite, and smoky, amethyst and rose quartz. Valentine has stated that his signature work with cast polyester resin gave him a means to replicate the hazy atmospheric conditions of Southern California sky,[6] yet the surface of these works, often described as precise, recalls the polished and faceted surfaces found in gem-working and the crystalline clarity of Colorado atmosphere. His extensive and seductive palette, often jewel-like, also evokes polished stones. He clearly articulates this aspect of his work: "I guess I was always interested in that kind of transparent colored space. The outside surface of a jewel is stunning of course, but I was always mesmerized by the inside, the light coming from beyond."[7]

During the war years 1941–1945 Valentine and his parents left Fort Collins and travelled constantly as his father pursued employment as part of the war effort. Valentine notes that his parents joked about living in forty-one states during this time period though he believes that they *slept*, not lived in forty-one states, traveling like vagabonds and bedding down in trailers, hotels, and cheap apartments.[8] In these travels a seminal experience was time spent in Lander, Wyoming in 1945. As part of a government priority during the war Valentine's father worked on a gas line, following the line from Colorado into Wyoming near Fort Washakie in the Wind River Reservation. Valentine's aunt and uncle lived in this area and he often notes that experiences rock-hounding with his uncles, and visiting a rock shop in Lander (another area rich in mineral deposits) cemented his love of precious stones. Valentine's mother shared a fascination with gemstones and collected Native American jewelry, a practice that Valentine continues to this day.[9]

At the close of the war in 1945 Valentine's parents returned to Fort Collins, purchasing a small house with a stable and a chicken coop south of the city on the graveled Spring Creek Road, at that time a very rural area surrounded by agricultural farmland. Valentine remembers his family returning to the Wind River Reservation to attend a wild horse round-up at which they purchased horses to bring back to their Fort Collins' home.[10] Valentine rode horses and grew up among the trappings of the West. As a testament to his love of Colorado the artist's current studio in Los Angeles is home to a collection of modern art coexisting harmoniously with an extensive collection of cowboy boots and spurs; the artist is rarely seen without his signature cowboy hat. Not costume, these physical objects embody a deep-felt identity with the artist's Colorado roots. In fact, Valentine often relates that his first attempts at serious drawing were renderings of horses.

De Wain Valentine, Fort Collins, CO, ca. 1949

Before the war Glenn Valentine was employed at the *Ghent Motor Company*, a local car dealership. Following the war he and Rouine opened their own. *Valentine Motor Mart* sold Packards and Jeeps. Even in a small rural community like Fort Collins cars were economically *and* culturally defining. A report entitled *Auto Industry Vital to Fort Collins* featured a photograph of Rouine and Glenn's business and asserted "this industry represents a very vital part of the general economy of the community."[11] Valentine's boyhood friends note that they quickly moved from obsessions with horses to cars, boats and girls.[12] Classmates recall Valentine's trademark convertibles.[13]

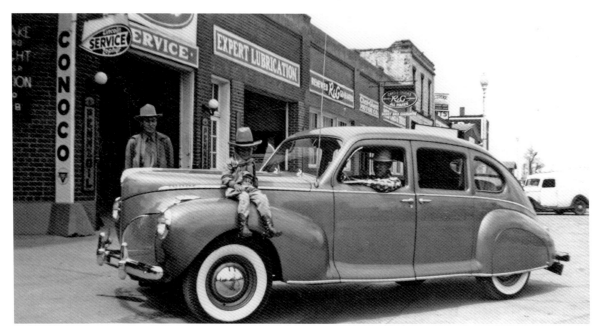

Glenn and De Wain Valentine, with Leo Chole at the wheel of 1939 Lincoln Sephyr, Fort Collins, CO, 1939

At *Valentine Motor Mart* Rouine and Glenn's son painted and finished cars as early as age twelve, beginning his experiments with synthetic materials at that time. In an early interview Valentine noted this "is where I got started using lacquers and being concerned with surfaces."[14] He adds, "My mom and daddy used to own a garage and I painted cars for them….I used to customize and buildup customized cars….custom cars were my thing."[15] He often applied twenty-plus layers to a car to achieve the surface he desired.[16] Later they added Mercury outboard motors and a Century Boat Agency to the dealership[17] that led to work with fiberglass and boats. By the early 1950s their son was working on plastic boat hulls.[18] Boyhood friends remember that they spent hours on area lakes water-skiing and experimented with adhering fiberglass to their skis.[19]

Valentine's familiarity with these materials was augmented by forward-thinking teachers in Fort Collins. At Lincoln Junior High School, Valentine was encouraged by his industrial arts teacher, John Warner, to experiment with Plexiglas. Aware of the boy's fascination with collecting and polishing rocks, Warner showed him how to cut the material on a band table saw and polish the edges to a pristine shine.[20] Valentine also remembers working with edge-lit Plexiglas, the precursor to fiber optics, another early experience key to his mature work, especially his 1970s installations. Valentine wrote:

I was making drawings of works using a combination of klieg lights and laser beams. I kept wanting to find a way to make a laser beam bend, and there was no ostensible way to do that. Then it flashed in my head that in junior high school I had done some light pieces with fiberglass that would later be termed "fiber optics" – but I didn't know it had a name then…using the principles of fiber optics, I could light a piece of Plexiglas tubing and make the light bend…so…it just clicked into my head that I could make a line, and make it curve, and also make it illuminated – by using acrylic rod.[21]

A second critical figure was shop teacher Perry Knight, still renowned throughout the Fort Collins community as a master carpenter and technician. Valentine first worked with Knight at Lincoln, and later at Fort Collins High School. Knight responded to Valentine's craftsmanship and introduced him to resins and the potential of introducing color into cast forms. Valentine began to cast polyester resin as early as 1950, creating jewelry, much of which he gifted to his mother.[22] He recalls cutting and polishing "emerald, diamond, and heart shapes" created with store-bought polyester liquids and ceramic molds and attempting to bake the materials in his mother's oven.[23] Valentine's interest is in keeping with his love of gems and minerals but also parallels developments in the history of the plastic industries. The colors in the prevalent pre-war plastic, Bakelite, were prone to discoloration and fading. When breakthroughs were announced in the late 1920s and 30s, cast resins were described as "capable of simulating nature's gems."[24]

Valentine's introduction to plastics occurred during a transitional, and pivotal, time in American culture. Scientists had risen to the challenge of producing new technologies, including pioneering work with synthetics, for wartime needs. American production of plastic tripled during the Second World War. [25] Large chemical companies like Monsanto developed resins in the 1940s which were used to add durability, aerodynamics, and waterproofing, to planes and boats. [26] Acrylic plastics, including the Plexiglas developed by Rohm and Haas in the late 30s, found military applications such as the fabrication of cockpit windshields. [27] Although Colorado was clearly not the center of aviation manufacturing, small local aircraft companies provided parts for the military and distributed scraps to Colorado schools. [28] Valentine's teachers procured these materials from regional plants and made them available for class projects.

Towards the close of the war the American press promoted plastics as a panacea, not only for wartime needs, but for all aspects of modern life. In a 1943 *Newsweek* article, industry was urged to create "a plastic postwar world" that bespeaks American aspirations for utopian living. "For the postwar world, there are promises of plastic houses, of plastic private airplanes, of thousands of other articles that will heighten the comfort of everyday living."[29] American companies faced the challenge of transitioning plastics from wartime to peacetime needs – some did so successfully, others failed. Cultural historian Stephen Phillips notes that by 1946 the first fiberglass plastic car had been constructed, and that by the mid-1950s kits to build do-it-yourself vehicles had swept the nation as a phenomenon.[30] Plastic was presented as the miracle material for the home – easy to clean, sanitary and hygienic. And plastic of all kinds found new uses in signage, the car industry, and a vast array of domestic products. Rohm and Haas, for example, found that their trademark material, Plexiglas, could be exploited for internally lit commercial signage initially utilized by the gasoline industry[31] to promote their products to American car owners. (In Valentine's Venice studio one of his prize possessions was a Mobil vitreous enamel on steel sign, bearing the companies trademark image of Pegasus.) Valentine's early

forays with plastics occurred at the very beginning of this wave and the consequent change in the visual American landscape. Fidel Danieli writes of Valentine's early experiments, "…he explored areas categorized today as hobby craft jewelry, but at this early date it must be remembered such materials as casting resins, plexiglass and colored dye laminates were still considered unusually exotic, particularly at this educational level."[32]

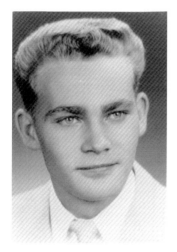

De Wain Valentine, Fort Collins High School senior picture, 1954

The early 1950s were halcyon years, not only for a country free from the hardships of war, but for the students at Fort Collins High School where Valentine clearly flourished. Involved in over fourteen extracurricular activities including Square Dance Club, Spanish Club, Speech Club, A Cappella Choir, Drama, and Ski Club, Valentine is remembered by friends as popular and artistic.[33] Noticeably absent from the list of Valentine's high school activities is participation in the visual arts, a curriculum area that he found insufficiently serious and overtly craft-based in orientation.[34] These distinctions would become more evident when later, as an art student at the University of Colorado in Boulder, he would read R. G. Collingwood's 1938 text, *Principals of Art* as part of his minor in the philosophy of aesthetics.

His critical secondary school experiences were, instead, in the industrial arts, a viable alternative path in the development of modernism and modern design. Self driven, Valentine supplemented these experiences by painting in a makeshift studio in his grandmother's garage, referencing art books at the local library, and subscribing to a mail order drawing course out of Chicago that emphasized *trompe l'oeil* effects.[35] After graduation from Fort Collins High School in 1954 Valentine moved to Boulder to pursue painting, arriving in a 1948 red Cadillac convertible.

Valentine studied in Boulder from 1954 to 1960, receiving both a BFA and an MFA. His education was encompassing. Under the direction of faculty members Roland Reiss, Bud Black and Lynn Wolfe he remembers working with a wide variety of techniques and materials, while never relinquishing his experiments with synthetics.[36] Valentine's tenure in Boulder corresponded to the beginnings of a storied visiting artist program that brought cutting-edge luminaries to campus. Mark Rothko visited during the summer of 1955 following Valentine's freshman year; Valentine's father, worried about the financial stability of a career in art, forced his son to take a summer session in accounting instead of enrolling in Rothko's class.[37] In 1960 Valentine studied under Clyfford Still, an experience he recounts as transitional. Then fully immersed in expressionist painting, Valentine recounts Still urging him to "kick his heroes out of his work and find his own way," a lesson that Valentine took to heart as he transitioned into a professional career working three-dimensionally with various kinds of foam and resin plastics.[38] From 1960 through 1965 Valentine lived, taught, and worked in the Boulder and Denver area, primarily creating works with fiberglass and exhibiting at The Gallery (later known as the Brina Gallery) in the Cherry Creek area, the only serious art gallery focused on contemporary art. In 1965, Reiss asked Jack Hooper, a visiting artist in Boulder and a professor at U.C.L.A. to look at Valentine's innovations with plastic. The visit resulted in Valentine's move to Los Angeles. Valentine would return to Colorado for two summers at the Artist in Residence Program at the Aspen Institute for Humanistic Studies in 1967 and 1968.[39] The *Aspen Times* reported that Valentine's large plastic sculptures signaled the future.[40]

Jeffrey Miekle argues in his definitive text *American Plastic: A Cultural History*, that our country has had an ambivalent relationship with synthetic materials that at once signify high-tech miracles and the cheap, phony, disposable and impersonal. [41] His history chronicles both the successes and the failures of plastics during the postwar period including a discussion of the prevalence of artistic experiments that took place across the country, not only in California. In 1970, for example, the Milwaukee Art Center organized *A Plastic Presence,*

an exhibition featuring almost fifty artists working with fiberglass, nylon, cast resin, polyurethane foam and various other synthetic resources. Miekle writes that the critical response to this exhibition was measured, noting a lack of innovation with the materials themselves.[42] What most reviewers did not recognize was that Valentine, included in the exhibition, was already an innovator. A full four years before the exhibition, in 1966, he had developed his own chemical compound, Valentine MasKast resin, allowing for unheard of scale coupled with chromatic luminosity. Peter Plagens, in his pioneering text *Sunshine Muse*, calls Valentine "the technician *par excellence* in the material."[43] Miekle also argues that few of the artists of the 1960s had come to grips with plastic's "cultural meanings."[44] He cites Claes Oldenburg and Les Levine, two artists whom Valentine worked with during his Aspen residencies, as examples of artists who understood the problematic cultural meanings – the materialistic, throwaway implications of a plastic culture.[45] Valentine's work, I believe, reflects the successes of the material – the sheer beauty and aesthetic potential. Born from his love of Colorado geology and atmosphere, as well as a love of postwar technology and culture that he first immersed himself in during his years in Fort Collins, Valentine celebrates plastic as a material that can evoke the sublimity of both a time period and the natural environment. The complex geography of his work, born from a sophisticated understanding of time and place, is rightly lauded for its importance in American art history. Valentine's work deserves to be known and understood in the state where it was born.

— Linny Frickman, Fort Collins

ENDNOTES

1 Lewis W. Story, *The 73rd West Annual* (Denver: Denver Art Museum, 1971), 38.

2 Peter Frank, *De Wain Valentine 1965-1972: Toward a Disembodied Minimalism* (San Diego, California: Scott White Contemporary Art, 2008) unpaginated

3 Commonwealth Projects Production, *From Start to Finish: The Story of Gray Column* (Los Angeles, California: The Getty Conservation Institute, 2011), film.

4 Tom Learner, Rachel Rivenc, and Emma Richardson, "In Conversation with De Wain Valentine," in *From Start To Finish: The Story of Gray Column* (Los Angeles, California: The Getty Conservation Institute, 2011), 6.

5 Fort Collins History Connection, "Contexts: Colorado Gold Rush, Early Settlement, and the Creation of Fort Collins, 1844-1866" (accessed 31 May 2012). <http://history.poudrelibraries.org/archives/contexts/colorado.php>

6 Stephanie Hanor, "The Material of Immateriality" in *Phenomenal: California Light, Space, Surface*, ed. Robin Clark (Berkeley, Los Angeles, London: University of California Press, 2011), 128.

7 Learner, Rivenc, and Richardson, 6.

8 De Wain Valentine, telephone conversation with the author, 23 May, 2012

9 Reginald Hayworth, interview with the author, 11 May, 2012

10 Valentine, telephone conversation.

11 Fort Collins History Connection, "Valentine Motor Mart" (accessed 2 May 2012). <http://history.poudrelibraries.org/cdmrr/item_viewer.php>

12 Ralph Schneider, telephone conversation with the author, 12 May, 2012

13 Valentine's love of convertibles was brought up in multiple interviews with the artist and friends.

14 Kurt von Meier, "An Interview with De Wain Valentine," *Artforum,* vol. VII, issue 9 (May 1971), 55

15 In a personal correspondence with the author Valentine rephrased his memories of working at Valentine Motor Mart that he first recounted in the von Meier interview.

16 von Meier, 55.

17 Valentine, telephone conversation.

18 Fidel Danieli, "De Wain Valentine," *Art International,* vol. XII, issue 8 (November 1969), 36.

19 Schneider and Hayworth, interviews.

20 Valentine, telephone conversation.

21 Jan Butterfield, *The Art of Light and Space*, (New York, New York: Abbeville Press, 1993), 195.

22 Peter Frank, "De Wain Valentine," *Art News*, Vol. 72, No. 3 (March 1993), 103.

23 De Wain Valentine, telephone conversation with the author, 6 June 2012

24 Jeffrey L. Meikle, *American Plastic: A Cultural History* (New Brunswick, New Jersey: Rutgers University Press, 1995), 75-76.

25 Meikle, 1.

26 Stephen Phillips, "Plastics" in *Cold War Hothouses: Inventing Culture from Cockpit to Playboy,* ed. Beatriz Colomina, Annmarie Brennan, and Jeannie Kim (New York, New York, Princeton Architectural Press, 2004), 94.

27 Sheldon Hochheiser, *Rohm and Haas: History of a Chemical Company*, (Philadelphia, Pennsylvania: University of Pennsylvania Press, 1986), 60-61.

28 Thanks are due to Deborah Craven for her assistance in locating aircraft parts manufacturers in Colorado. An example is a wartime plant run by the Beech Aircraft Corporation near Boulder.

29 Phillips, 97.

30 Ibid, 100.

31 Hochheiser, 92.

32 Danieli, 36.

33 *Lambkin,* (Fort Collins, Colorado, Fort Collins High School, 1954), unpaginated

34 Secondary school art education in the 1950s was not as advanced as it is today. Copies of the Fort Collins High School Lambkin annuals support this assumption. The art club, for example, is noted for stenciling Christmas decorations on windows. Valentine considered this type of art activity "babysitting."

35 De Wain Valentine, telephone conversation with the author, 16 May, 2012

36 Ibid

37 De Wain Valentine, interview with the author, 7 April, 2012

38 Ibid

39 Valentine was a resident in the first and second session of the residency program at the Aspen Institute for Humanistic Studies. The program was sponsored by John and Kimiko Powers, Armand and Celeste Bartos, and Larry and Wynn Aldrich. Participants in the first year were Alan D'Arcangelo, Roy Lichtenstein, Claes Oldenburg, Les Levine, and Robert Morris. Colleagues in the second session were Robert Indiana, Carl Andre, Donald Judd, and Stanley Landsman. The history of the program is thoroughly documented in Dean Sobel, *One Hour Ahead: The Avant-garde in Aspen, 1945-2004* (Aspen, Colorado: Aspen Art Museum, 2004), 35-61.

40 Peggy Clifford, "Talk of the Times: Alice in Cultureland," *Aspen Times* (August 24, 1967)

41 Meikle develops this idea in his forward and it is established throughout the text.

42 Meikle, 232.

43 Peter Plagens, *Sunshine Muse: Art on the West Coast, 1945-1970* (Berkeley, Los Angeles, London: University of California Press, 1974, 1999), 122.

44 Meikle, 232.

45 Ibid, 237-241.

SELECTED WORKS

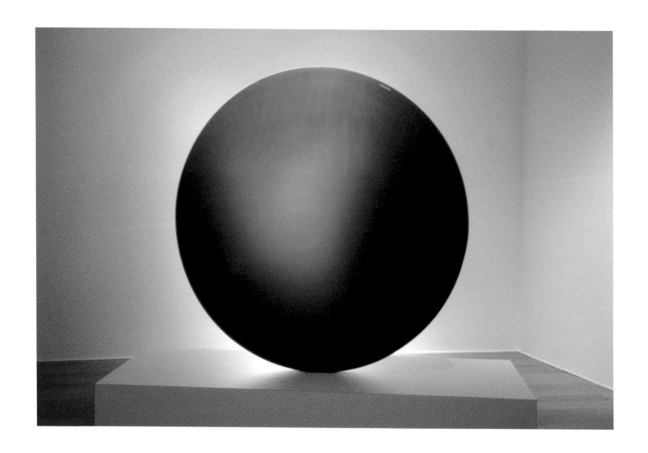

Circle Blue, 1970

Cast polyester resin
70″ diameter x 5″
Collection of the Artist

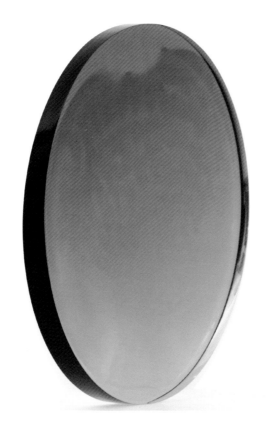

Circle Light Blue, 1970

Cast polyester resin
17 ½" diameter x 1 ½ "
Collection of the Artist

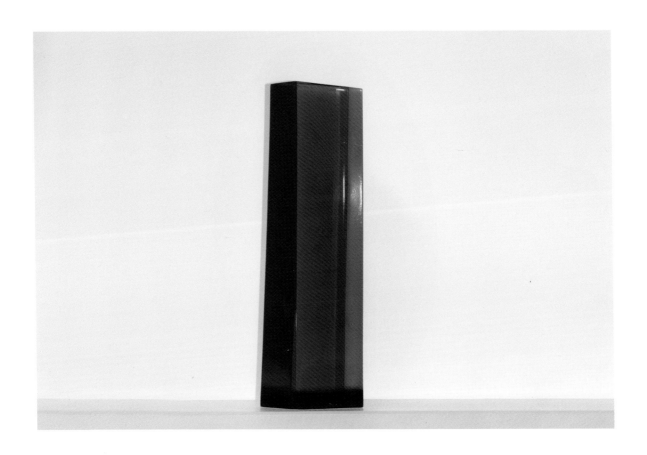

Column Rose, 1972

Cast polyester resin
27″ x 7 ½″ x 5″
Collection of the Artist

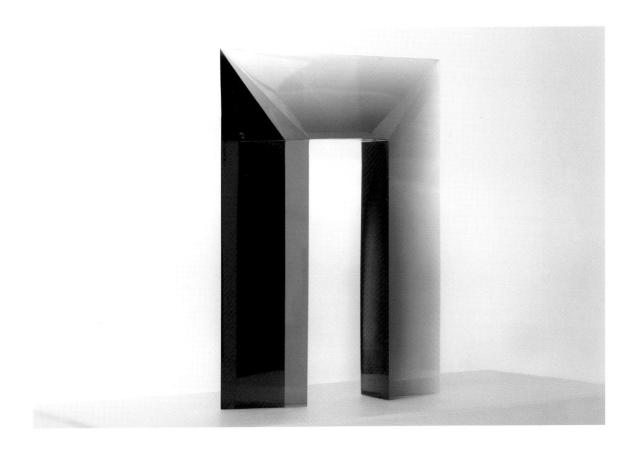

Portal Blue, 1971-2012

Cast polyester resin
22 5/8″ x 17 5/8″ x 3 13/16″
Collection of the Artist

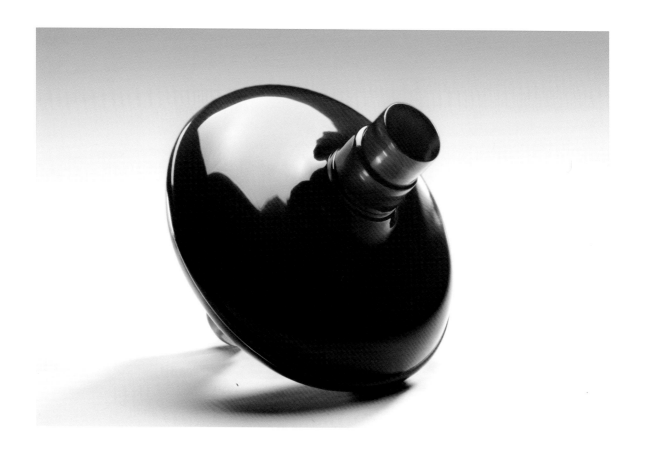

Red Top, 1966

Fiberglass reinforced polyester resin
14 ¾" x 14 ¾" x 14 ¾"
University Art Museum, CSU, Gift of Kimiko and John Powers
1976.1.2

WORKS IN THE EXHIBITION

Red Top, 1966
Fiberglass reinforced polyester resin
14 ¾" x 14 ¾" x 14 ¾"
University Art Museum, CSU,
Gift of Kimiko and John Powers
1976.1.2

Gray Disc, 1967
Cast polyester resin
11" diameter x 5"
Collection of Sid and Jayne Schetina

Circle Blue, 1970
Cast polyester resin
70" diameter x 5"
Collection of the Artist

Circle Light Blue, 1970
Cast polyester resin
17 ½" diameter x 1 ½ "
Collection of the Artist

Portal Blue, 1971-2012
Cast polyester resin
22 5/8" x 17 5/8" x 3 13/16"
Collection of the Artist

Column Rose, 1972
Cast polyester resin
27" x 7 ½" x 5"
Collection of the Artist

Gray Column, 1976 (maquette #1)
Cast polyester resin
23-1/2" x 11-3/4" x 9-3/4"
Collection of the Artist

Gray Column, 1976 (maquette #2)
Cast polyester resin
23-1/2" x 11-3/4" x 9-3/4"
Collection of the Artist

Gray Column, 1976 (maquette #3)
Cast polyester resin
23 ¾" x 11 ¼" x 9"
Collection of the Artist

Glass Column, 1991
Laminated glass
23"h x 7 ½" x 2 ¼"
Collection of the Artist

Water Window, 1994
Laminated glass on acrylic sheet
6 ½" x 7 ¾" x 1"
Collection of Sid and Jayne Schetina

Vertical Skyline 005, 2012
Acrylic on polycarbonate construction
72" x 48" x 3 1/4"
Collection of the Artist

Vertical Skyline 006, 2012
Acrylic on polycarbonate construction
72" x 48" x 3 1/4"
Collection of the Artist

documentary photographs of public works and commissions

Open Diamond Double Diagonal, 1984
Smoke laminated glass
96″ x 192″ x 48″
40 ¼″ x 1 ½″ x 30 ½″ framed image
Commissioned by, Los Angeles County, California State
Office Building, Van Nuys, California
Installation image: California State Office Building, Van Nuys
Photo credit: De Wain Valentine

Sky Gate, 1984
Laminated glass, bronze
172 1/2″ x 168″ x 96″
40 ¼ ″x 1 ½″ x 30 ½″ framed image
Commissioned by, The Frederick R. Weisman Art Foundation
Installation image: The Frederick R. Weisman Art Foundation,
Los Angeles, California
Photo credit: Thomas Vinetz

Water Column, 1984
Laminated glass, stainless steel fountain
84″ x 27″diameter
40 ¼″ x 1 ½″ x 30 ½″ framed image
Commission by, the Federal Reserve Bank,
San Francisco, California
Photo credit: De Wain Valentine

Sky Gate – Proposal, ca. 1985-86
Steel and glass construction
65.61′ height
40 ¼″ x 1 ½″ x 30 ½″ framed image
Proposed installation, Fondation Cartier, Jouy-en-Josas,
France
Photo credit: De Wain Valentine

Waterwall I, 1987
Laminated glass, bronze fountain
72″ x 72″ x 12″
40 ¼″ x 1 ½″ x 30 ½″ framed image
Commissioned by, Mr. & Mrs. Robert Colombato Family,
Palos Verdes, California
Daylight image
Photo credit: Thomas Vinetz

Waterwall I, 1987
Laminated glass, bronze fountain
72″ x 72″ x 12″
40 ¼″ x 1 ½″ x 30 ½″ framed image
Commission by, Mr. & Mrs. Robert Colombatto,
Palos Verdes, California
Illuminated night view image
Photo credit: Thomas Vinetz

Pacific Waterwall, 1988-90
Laminated glass
82″ x 228″ x 24″
40 ¼″ x 1 ½″ x 30 ½″ framed image
Commissioned by, The Pacific Enterprises Collection, Los
Angeles
Installation image: Valentine Studio, Venice, CA
Photo credit: Thomas Vinetz

Diamond Waterwall, 1989
Laminated glass, granite, bronze, fountain
156″ x 204″ x 120″
40 ¼″ x 1 ½″ x 30 ½″ framed image
Commissioned by, The Metropolitan, Forrest Cities, Los
Angeles, California
Installation image
Photo credit: William Nettles

(All dimensions are height x width x depth unless otherwise noted)

BIBLIOGRAPHY

Butterfield, Jan, *The Art of Light and Space*, New York: Abbeville Press, 1993

Clark, Robin, *Phenomenal: California Light, Space, Surface*. Berkeley, Los Angeles, London: University of California Press, 2011

Clifford, Peggy, "Talk of the Times: Alice in Cultureland," *Aspen Times* (August 24, 1967)

Danieli, Fidel, "De Wain Valentine," *Art International*, vol. XII, issue 8 (November 1969), 24-26

Frank, Peter, *De Wain Valentine 1965-1972: Toward a Disembodied Minimalism*. San Diego, California: Scott White Contemporary Art, 2008

_____, "De Wain Valentine," *Art News*, vol. 72, No. 3 (March 1973), 76

Hickey, Dave, *Primary Atmospheres: Works from California 1960-1970*. New York: David Zwirner, 2010

Hochheiser, Sheldon, *Rohm and Haas: History of a Chemical Company*. Philadelphia, Pennsylvania: University of Pennsylvania Press, 1986

Kosloff, Max, "Whitney Annual Sculpture, Whitney Museum," *Artforum*, vol. III, issue 6 (February 1969), 64

Learner, Tom, Rachel Rivenc and Emma Richardson, *From Start to Finish: The Story of Gray Column*. Los Angeles, California: The Getty Conservation Institute, 2011

Meikle, Jeffrey L., *American Plastic: A Cultural History*. New Brunswick, New Jersey: Rutgers University Press, 1995

Milwaukee Art Center, *A Plastic Presence*. Milwaukee: Milwaukee Art Center, 1969

Phillips, Stephen, "Plastics." In *Cold War Hothouses: Inventing Culture from Cockpit to Playboy*, edited by Beatriz Colomina, Annmarie Brennan, and Jeannie Kim, 91-123, New York: Princeton Architectural Press, 2004

Plagens, Peter, *Sunshine Muse: Art on the West Coast, 1945-1970*. Berkeley, Los Angeles, London: University of California Press, 1974, 1999

_____, "Five Arts, Ace Gallery," *Artforum*, vol. X, issue 2 (October 1971), 87

Sobel, Dean, *One Hour Ahead: The Avant-garde in Aspen, 1945-2004*. Aspen, Colorado: Aspen Art Museum, 2004

Story, Lewis W., *The 73rd West Annual*. Denver: Denver Art Museum, 1971

Von Meier, Kurt, "An Interview with De Wain Valentine," *Artforum*, vol. VII, issue 9 (May 1971), 54

COPYRIGHT AND IMAGE CREDITS